NATURALLY
NEW HAMPSHIRE
PHOTOGRAPHY

NATURALLYNH.COM

© 2013

WELTON FALLS STATE FOREST
ALEXANDRIA, NH

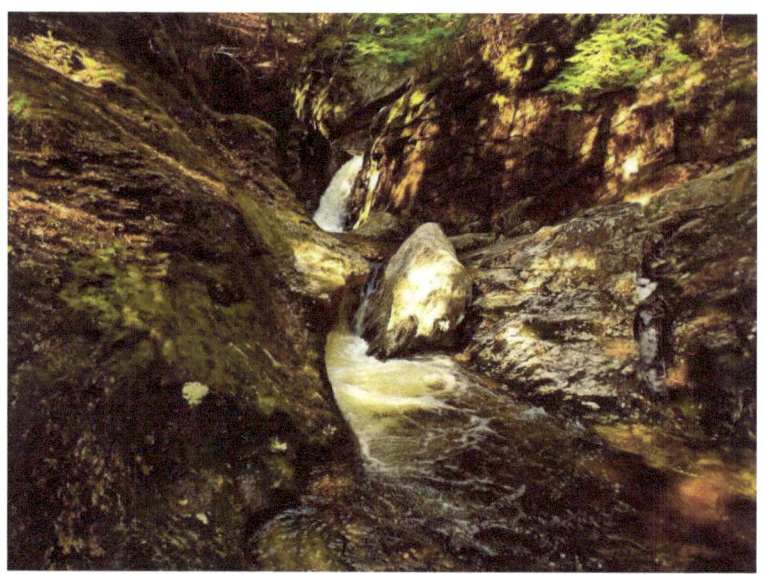

No matter how many goals you have achieved, you must set your sights on a higher one.
-Jessica Savitch

MOUNT CARDIGAN

ALEXANDRIA, NH

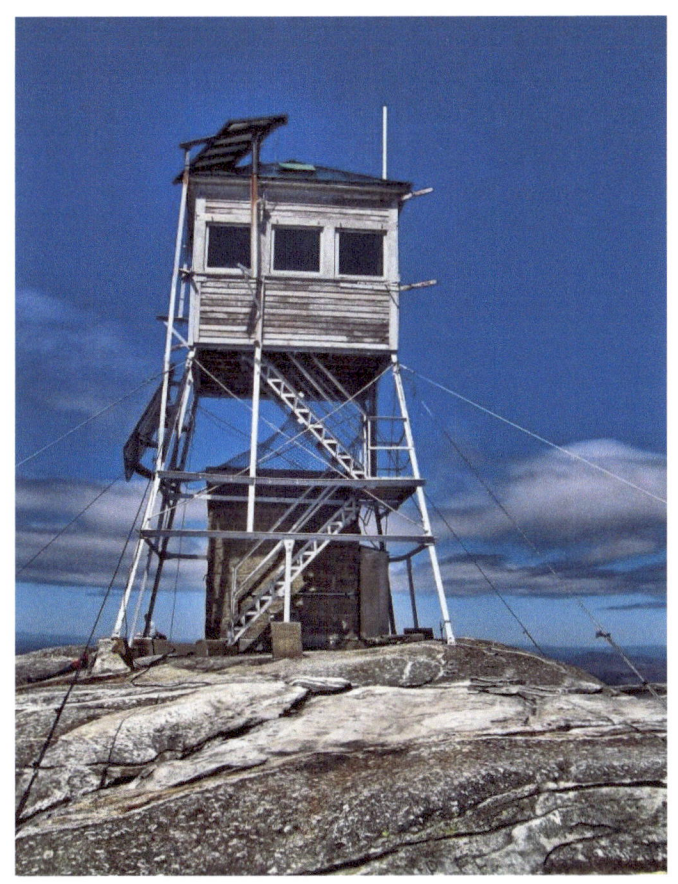

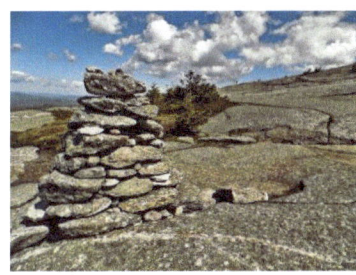

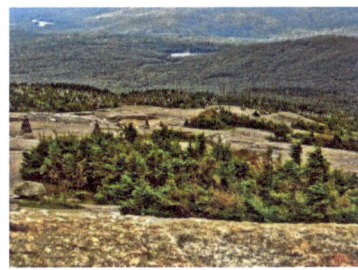

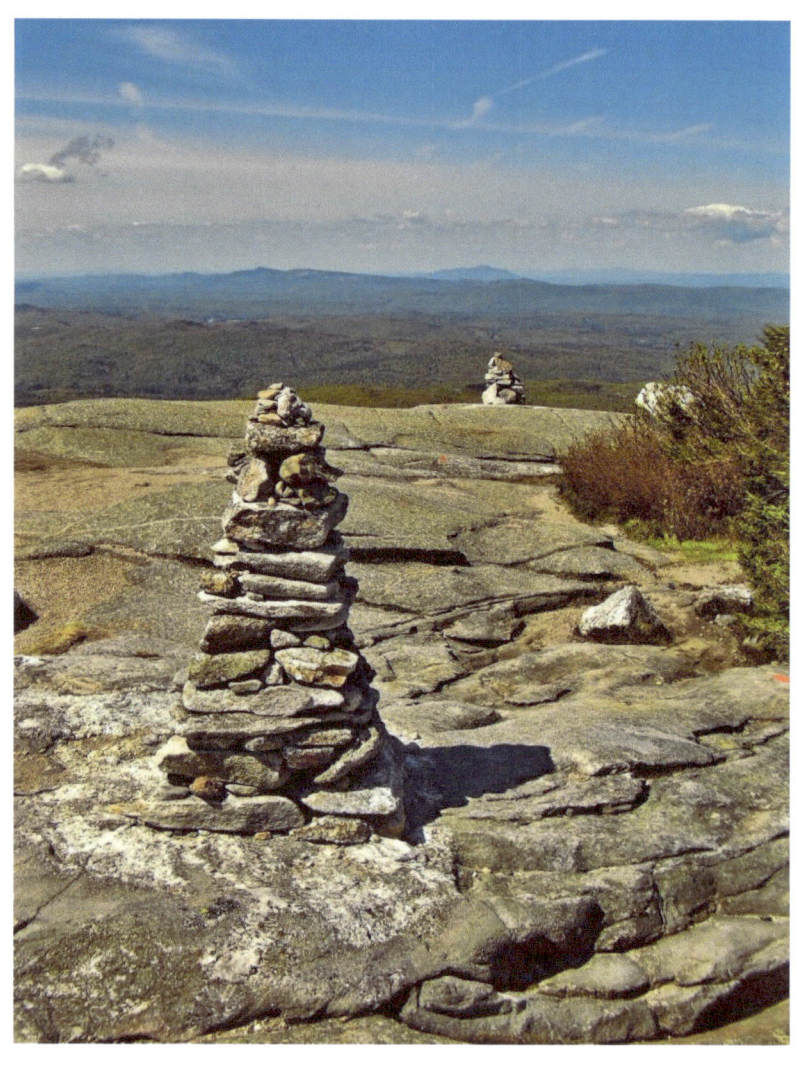

Clouds come floating into my life, no longer to carry rain or usher storm, but to add color to my sunset sky.
- <u>Rabindranath Tagore</u>

JANUARY

JANUARY

SPRING MEANS NEW BEGINNINGS...

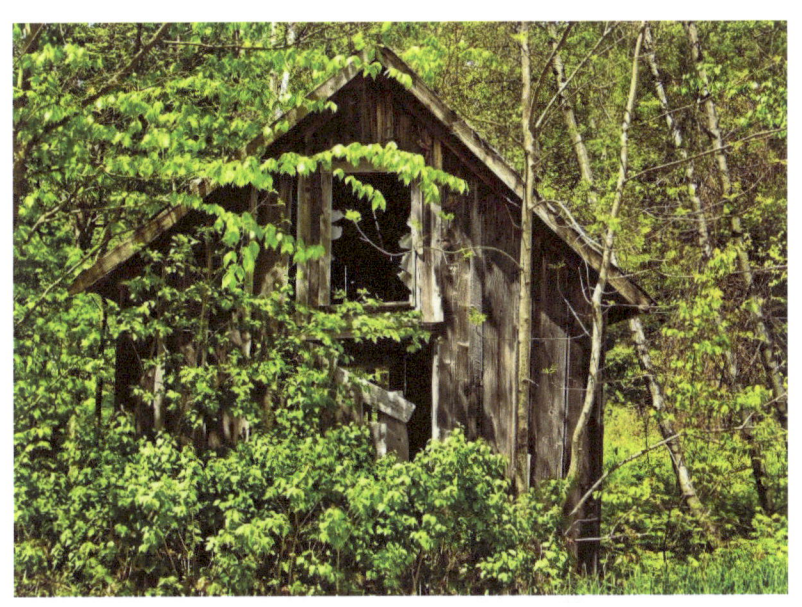

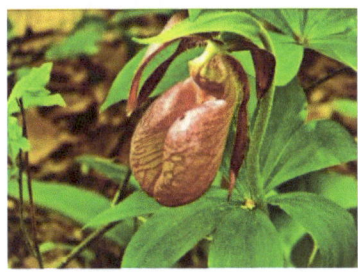

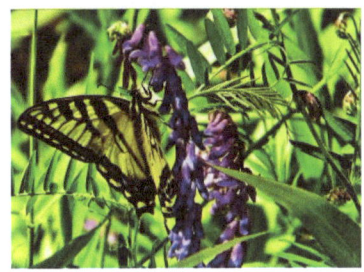

RAINBOW FALLS

PLYMOUTH, NH

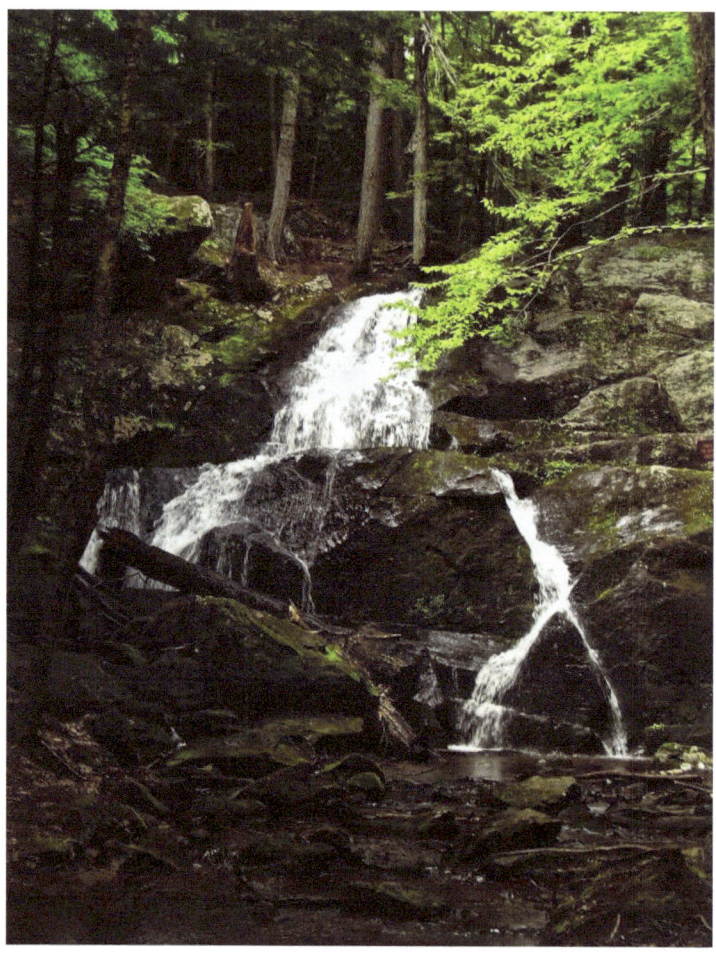

Every moment and every event of every man's life on earth plants something in his soul.
-<u>Thomas Merton</u>

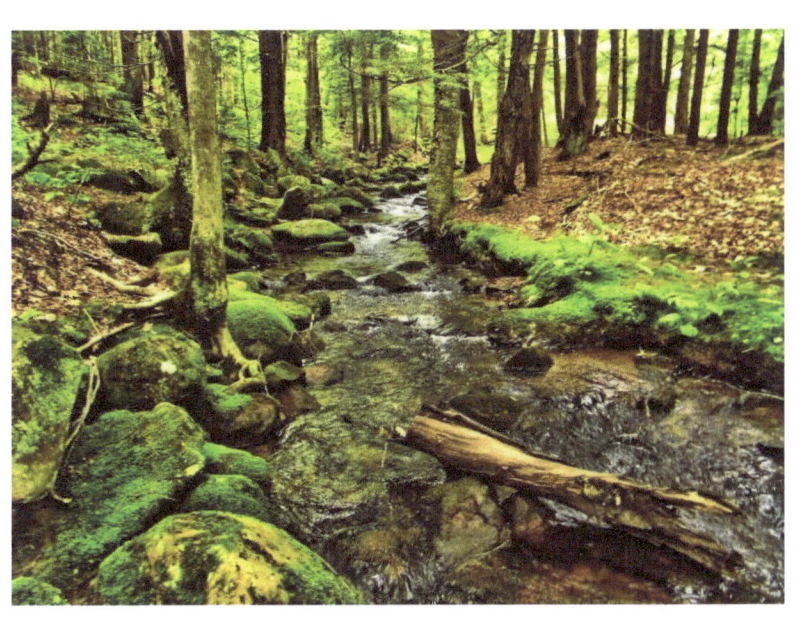

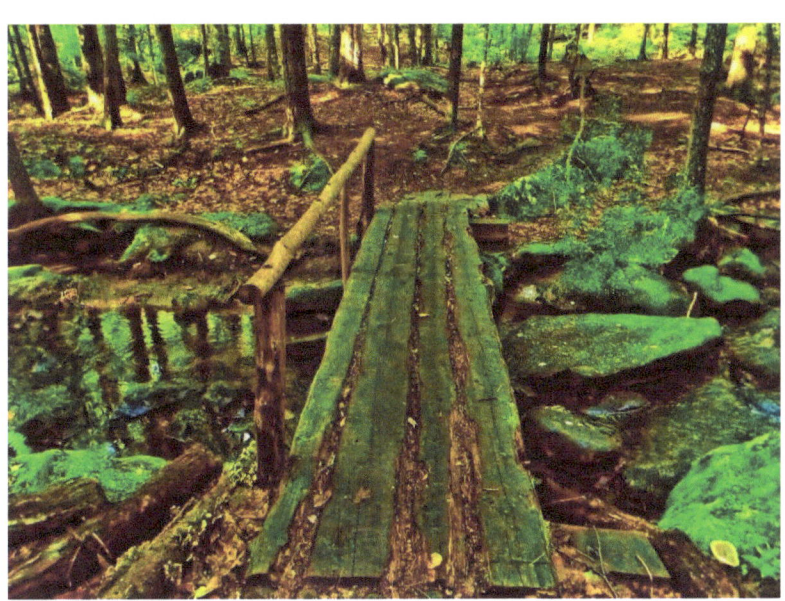

FEBRUARY

FEBRUARY

QUEEN ANNE'S LACE

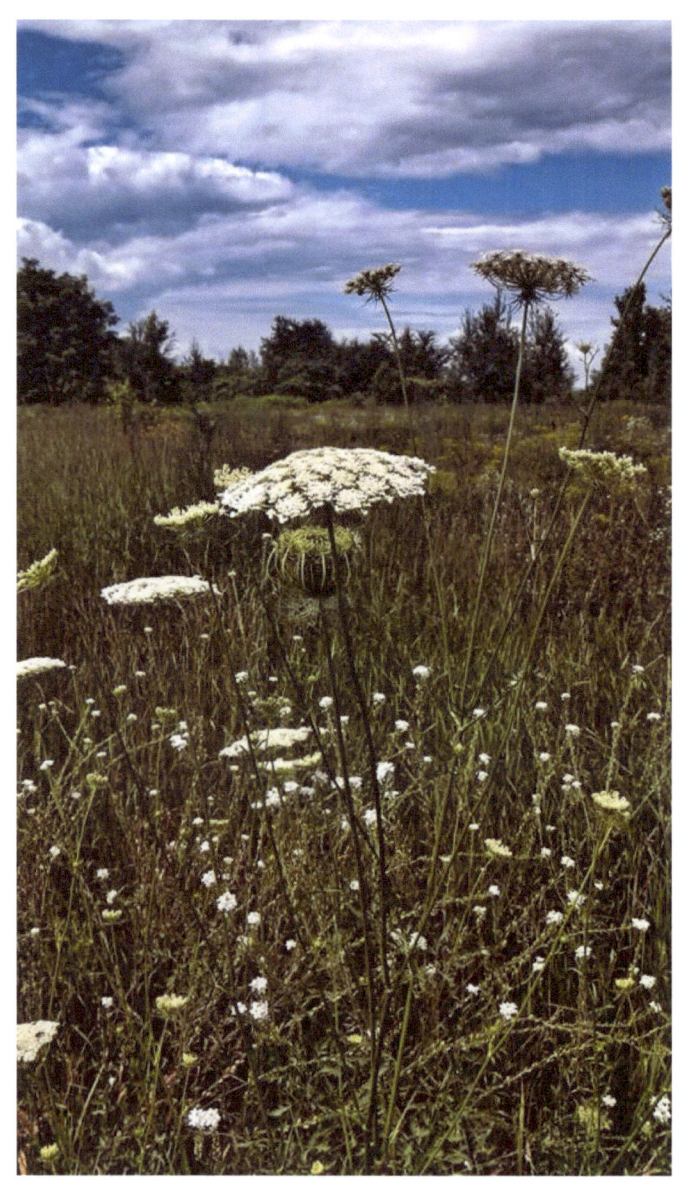

BLAIR BRIDGE – CAMPTON, NH

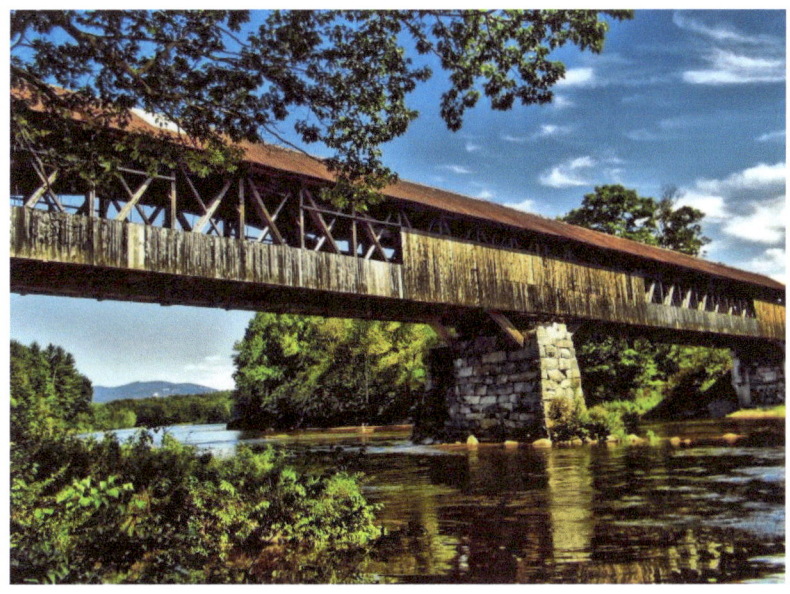

PROFILE FALLS – BRISTOL, NH

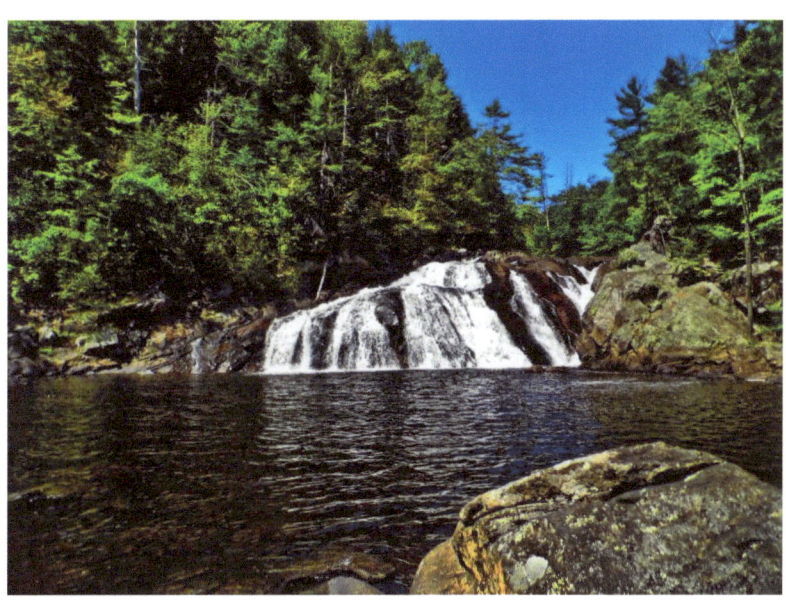

MARCH

MARCH

MOUNT LAFAYETTE & MOUNT LINCOLN – FRANCONIA NOTCH

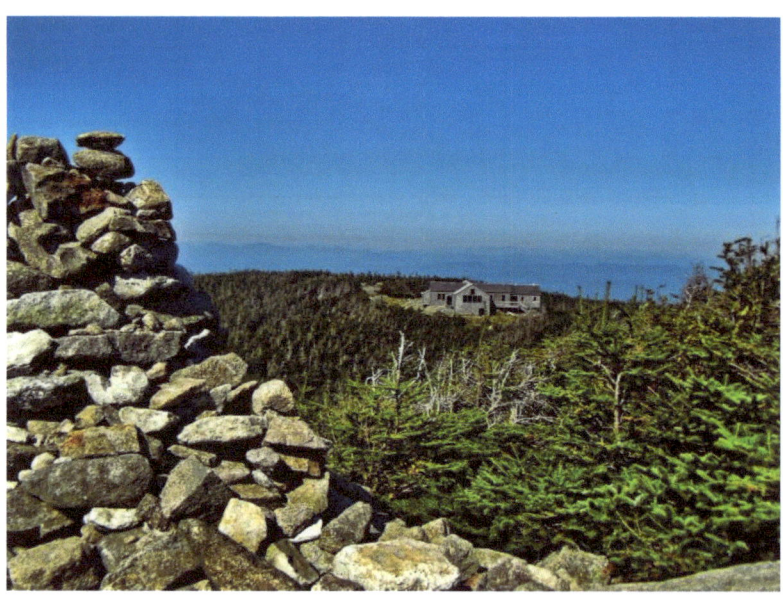

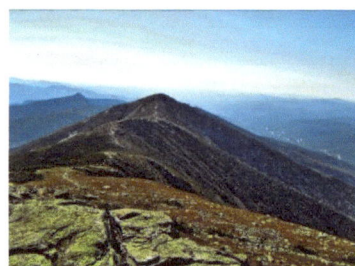
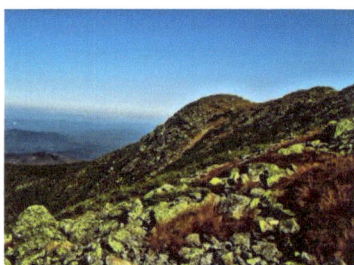
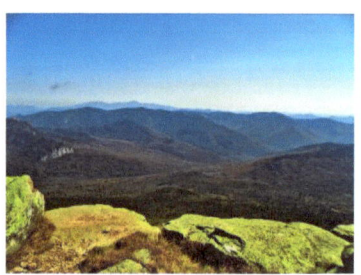
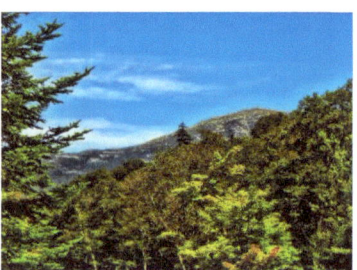

MOUNT LAFAYETTE

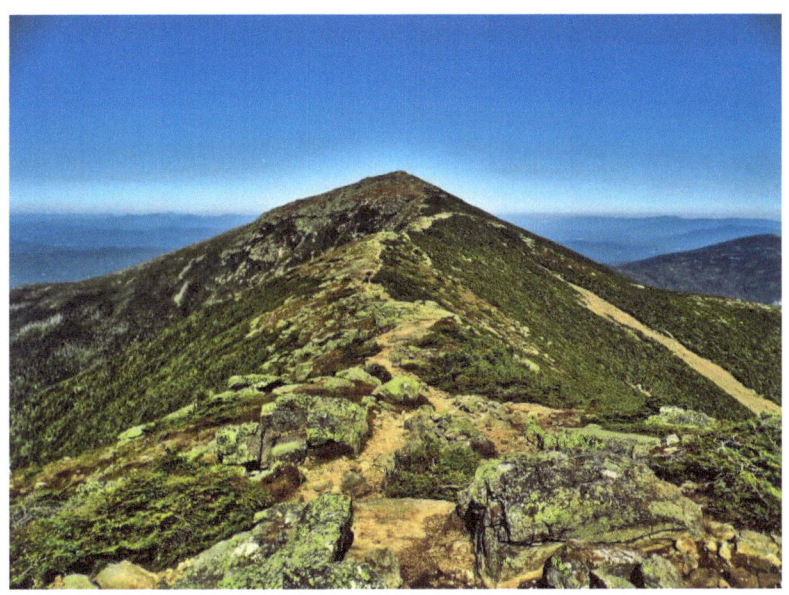

MOUNT LINCOLN

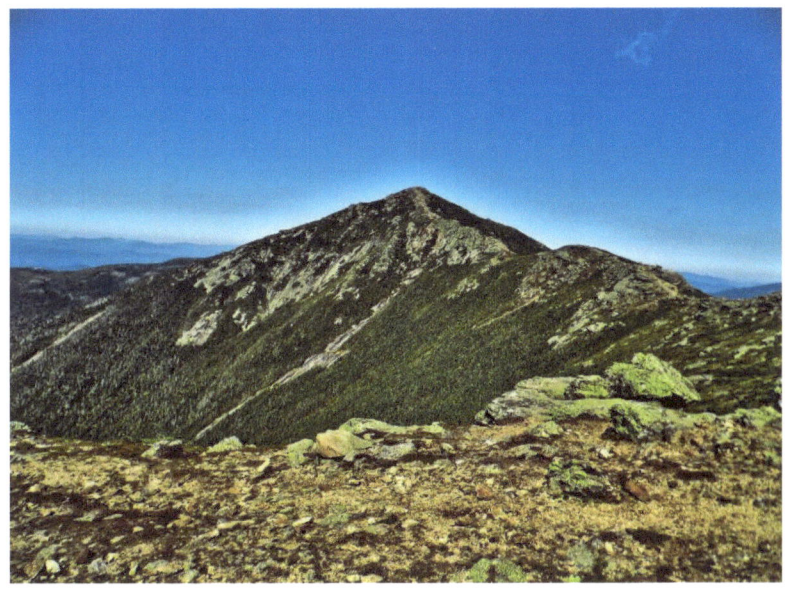

FRANCONIA NOTCH

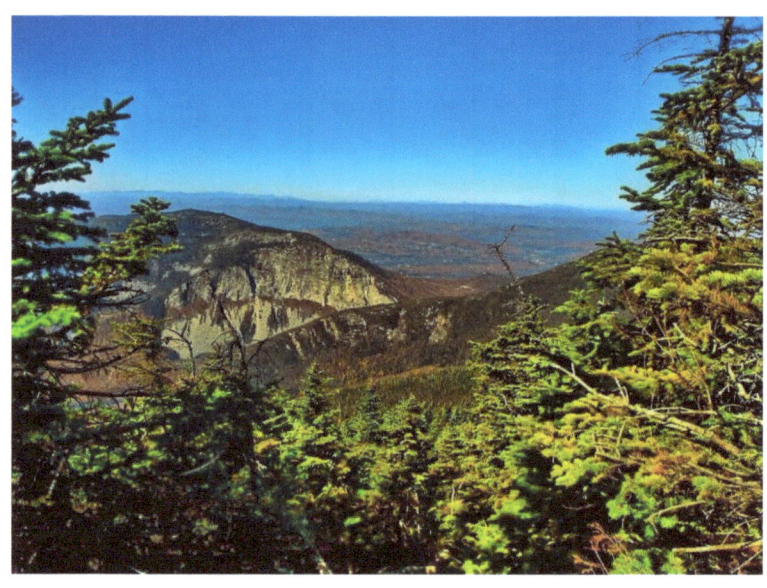

CLOUDLAND FALLS

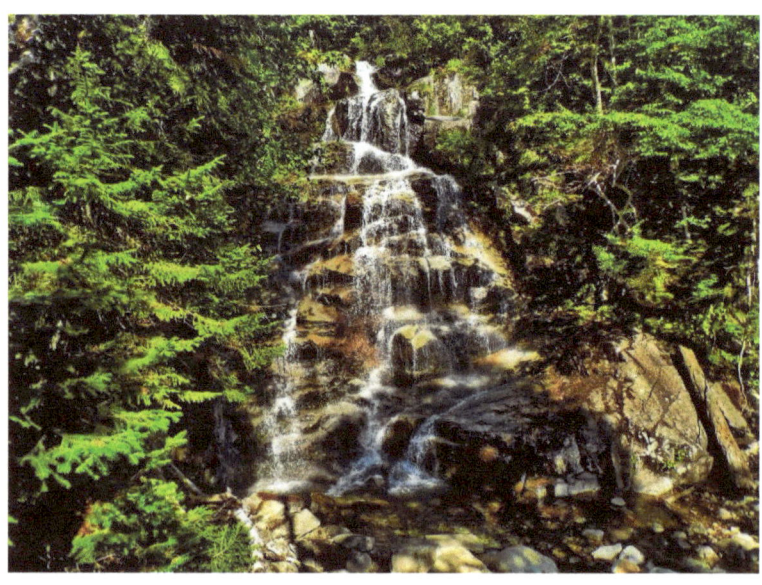

APRIL

APRIL

MOUNT KEARSARGE
WARNER, NH

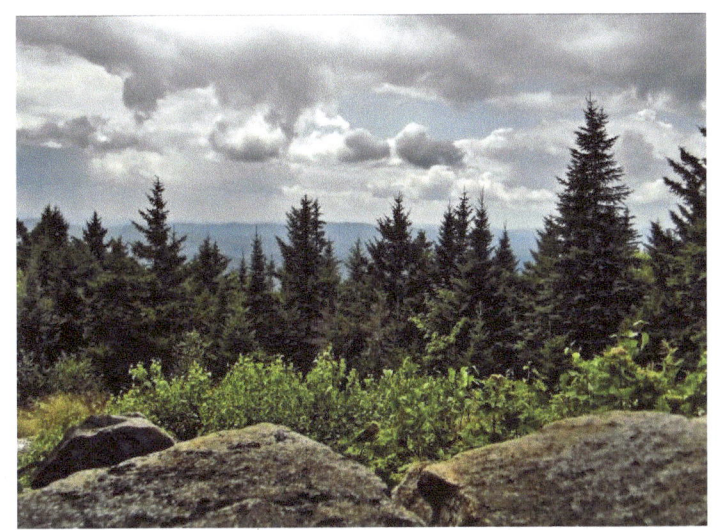

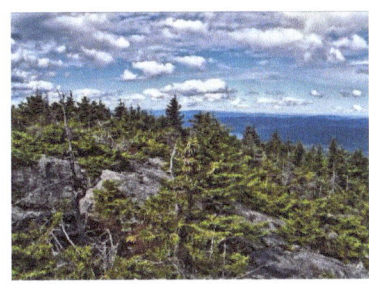

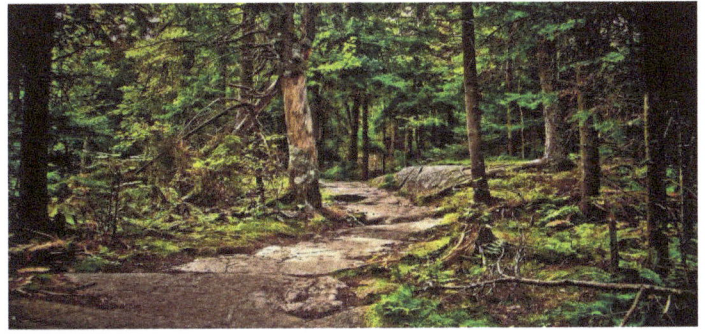

MOUNT MOOSILAUKE

BENTON, NH

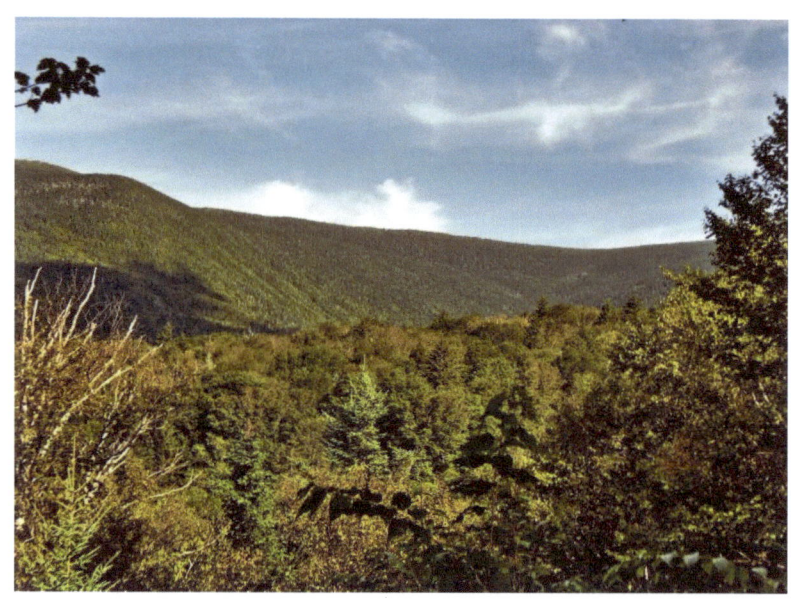

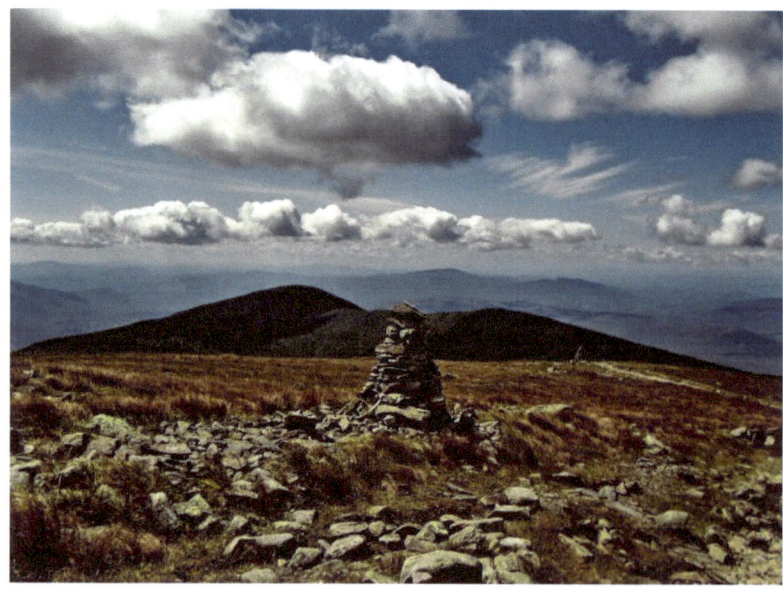

With self-discipline most anything is possible.
-Theodore Roosevelt

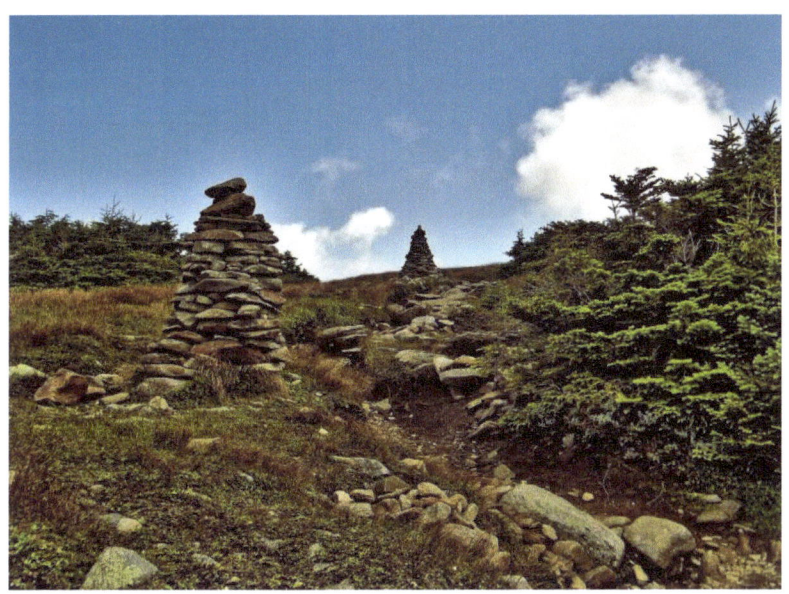

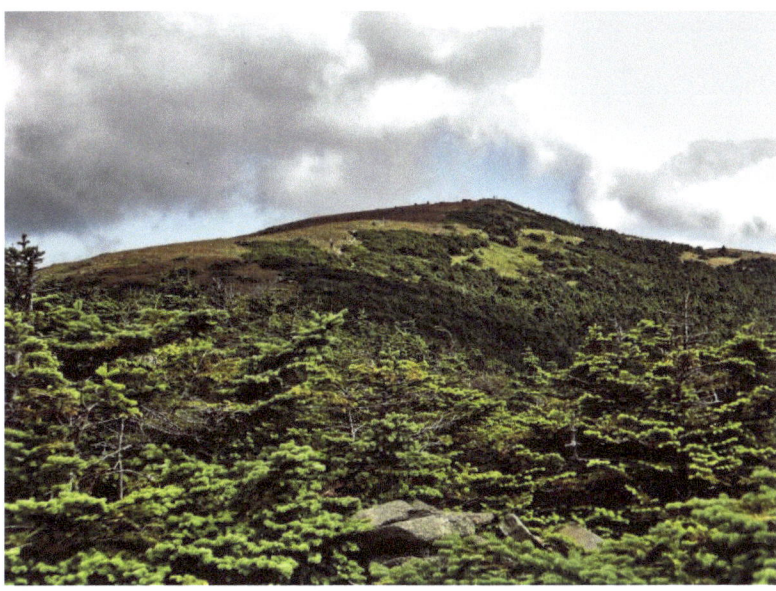

MAY

MAY

MOUNT CHOCORUA
CHAMPNEY & PITCHER FALLS

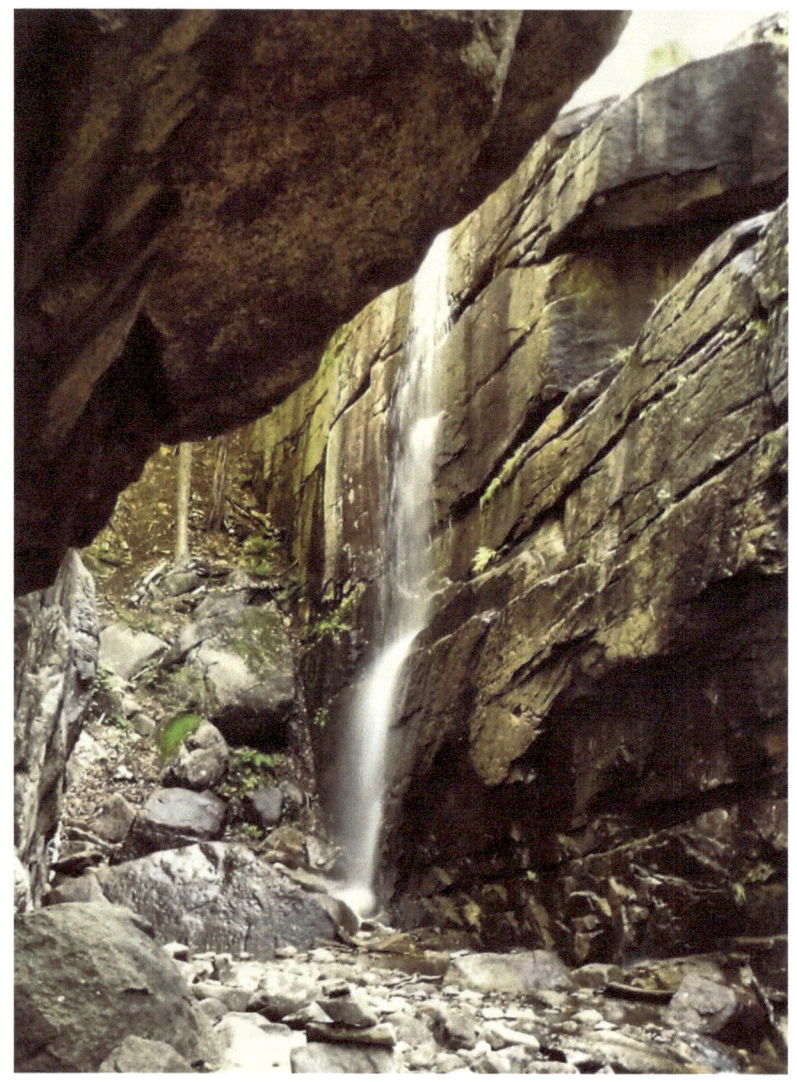

Pitcher Falls

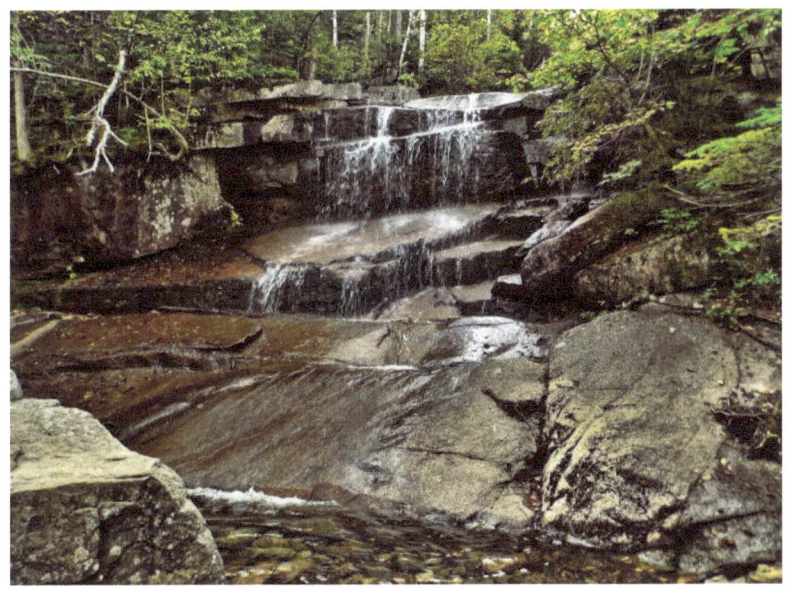

Champney Falls

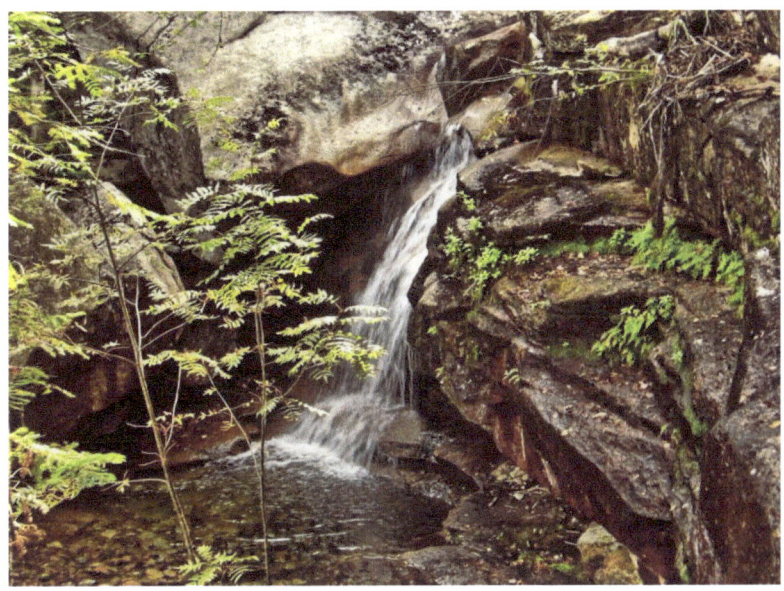

Upper Champney Falls

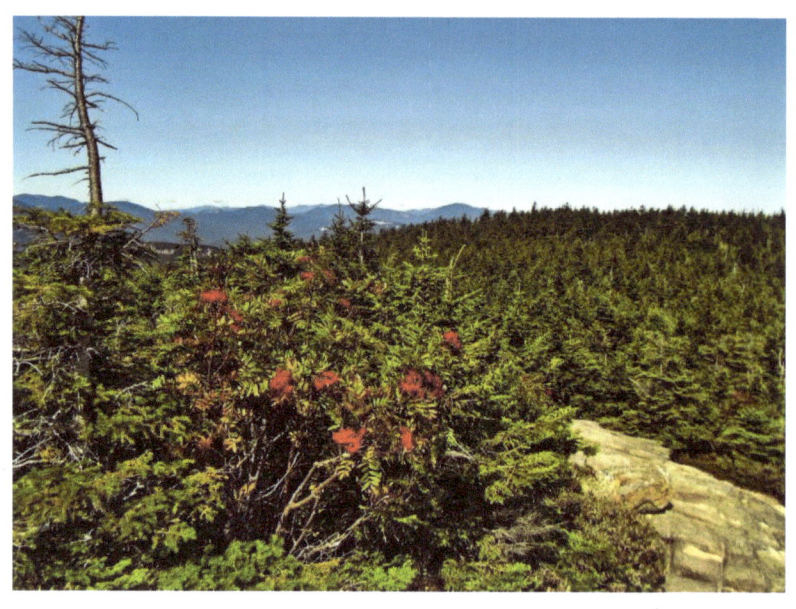

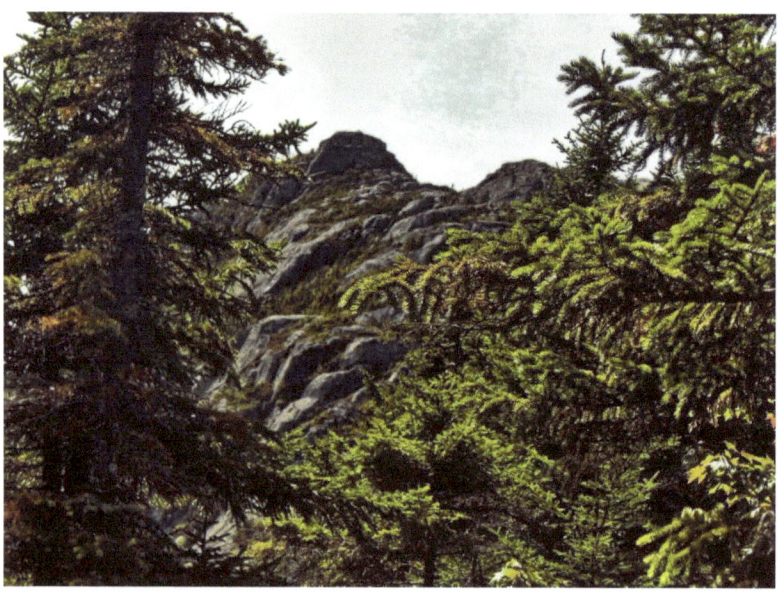

Mount Chocorua Summit

JUNE

JUNE

OLD HILL VILLAGE – HILL, NH

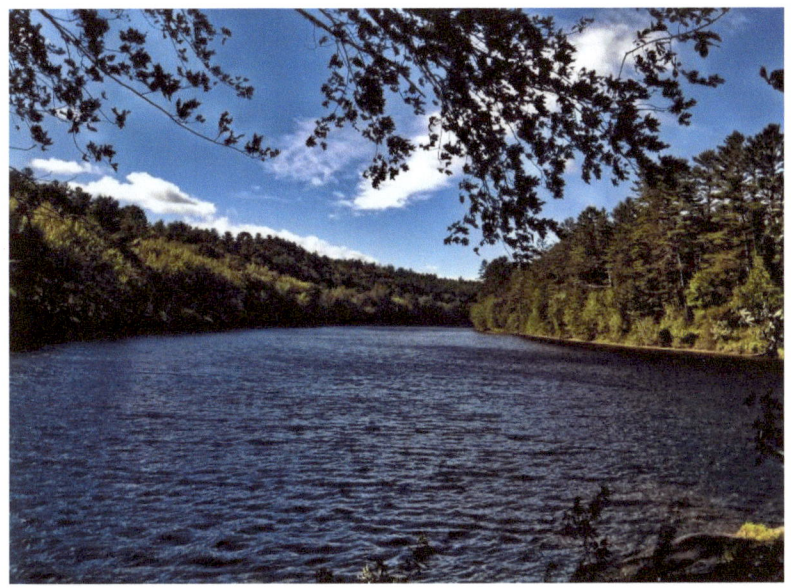

The Eddy

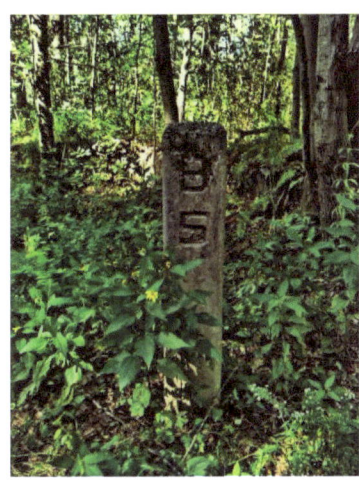 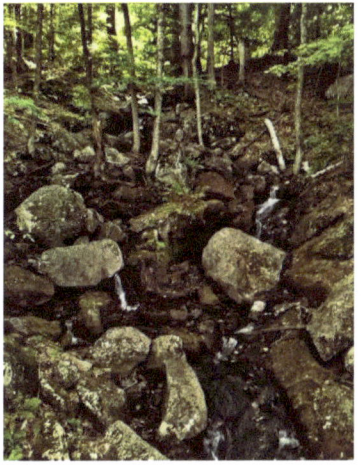

Mile Marker & Dyer Brook

MOUNT WELCH & MOUNT DICKEY
THORNTON, NH

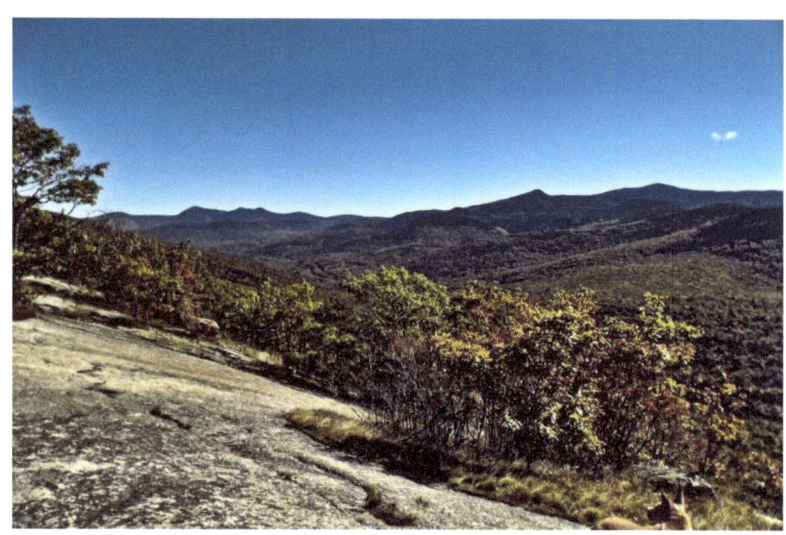

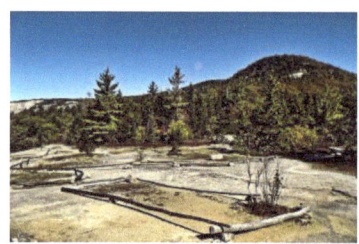
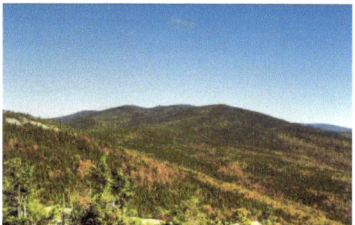
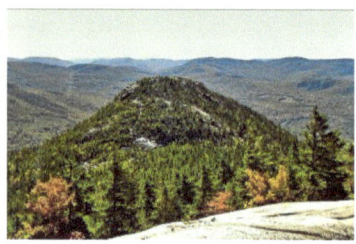
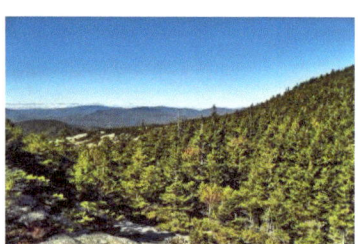

JULY

JULY

AUTUMN IN NEW HAMPSHIRE

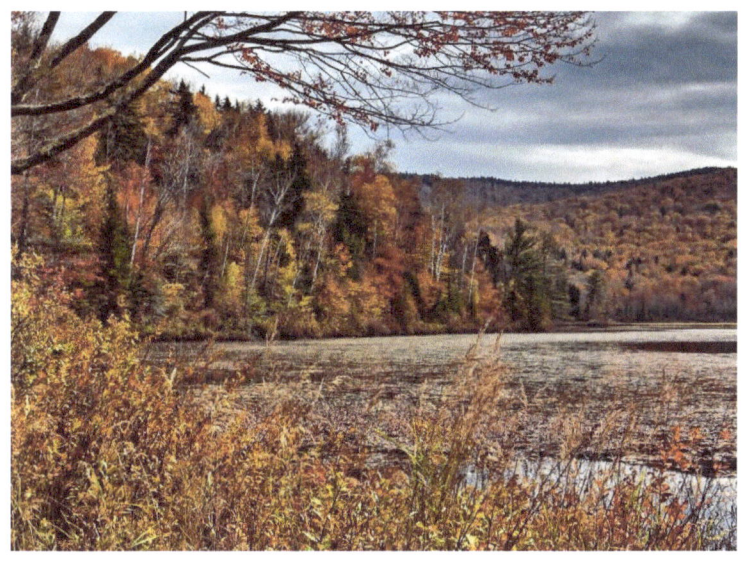

Elbow Pond

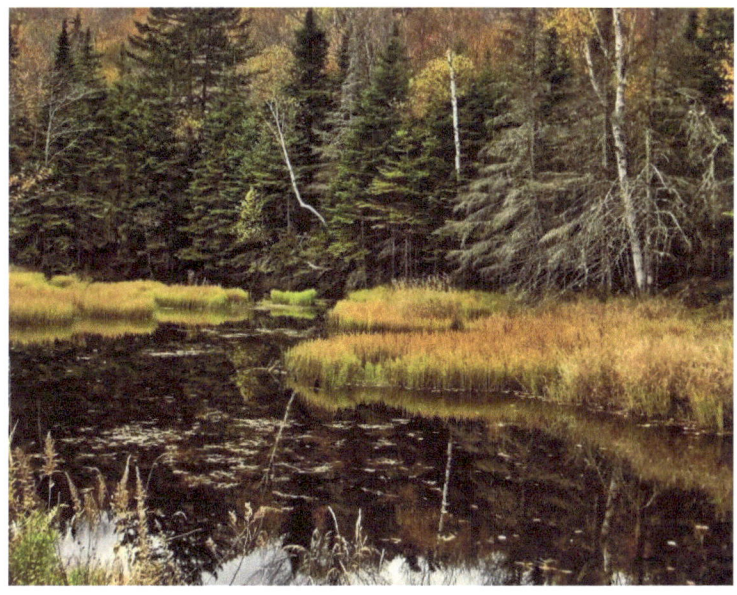

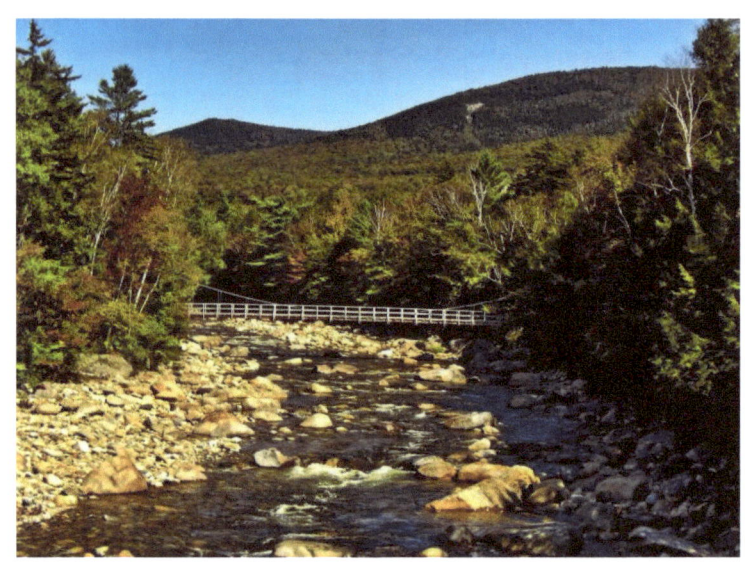

Lincoln Woods – Lincoln, NH

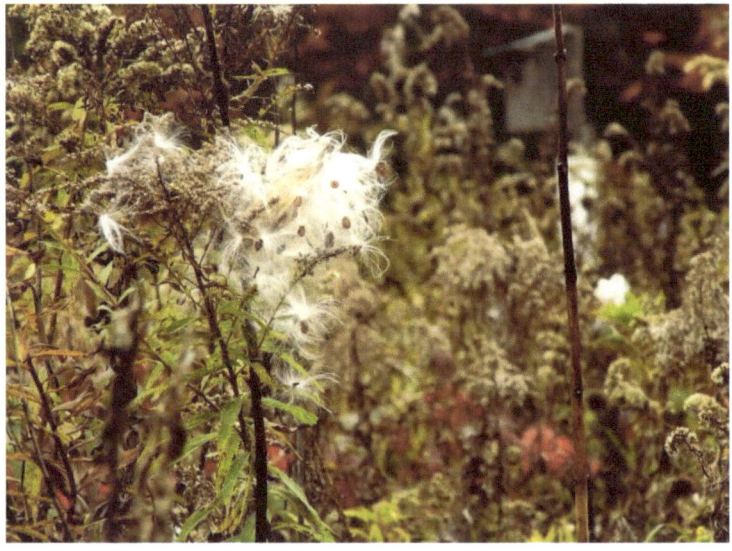

AUGUST

AUGUST

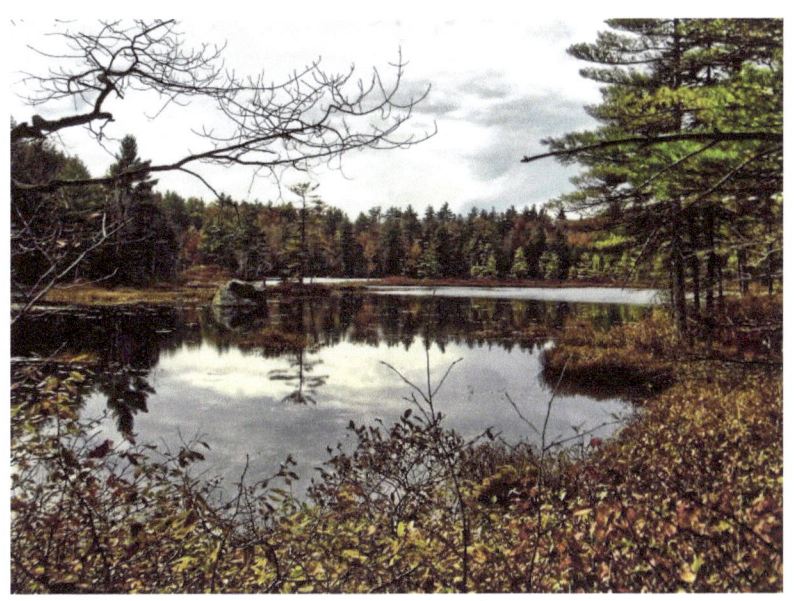

Poverty Pond – Hill, NH

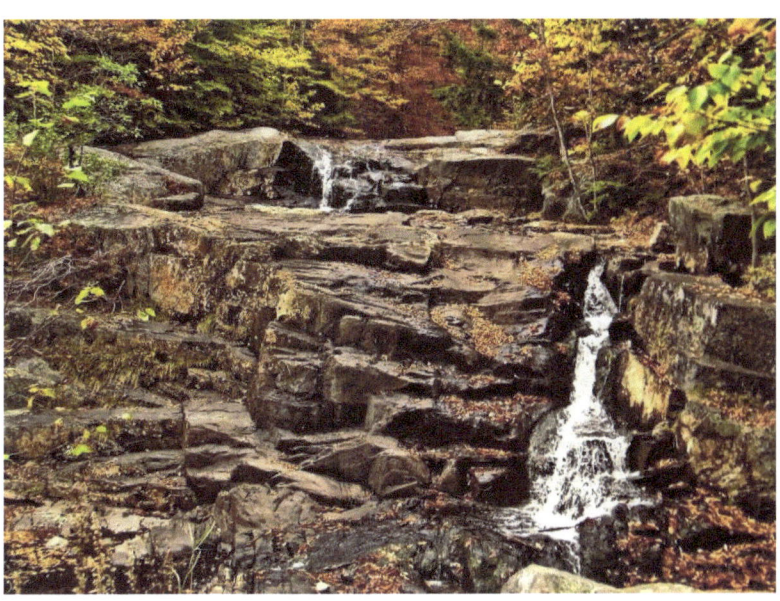

Ellsworth Falls – Stinson Lake Road, Rumney, NH

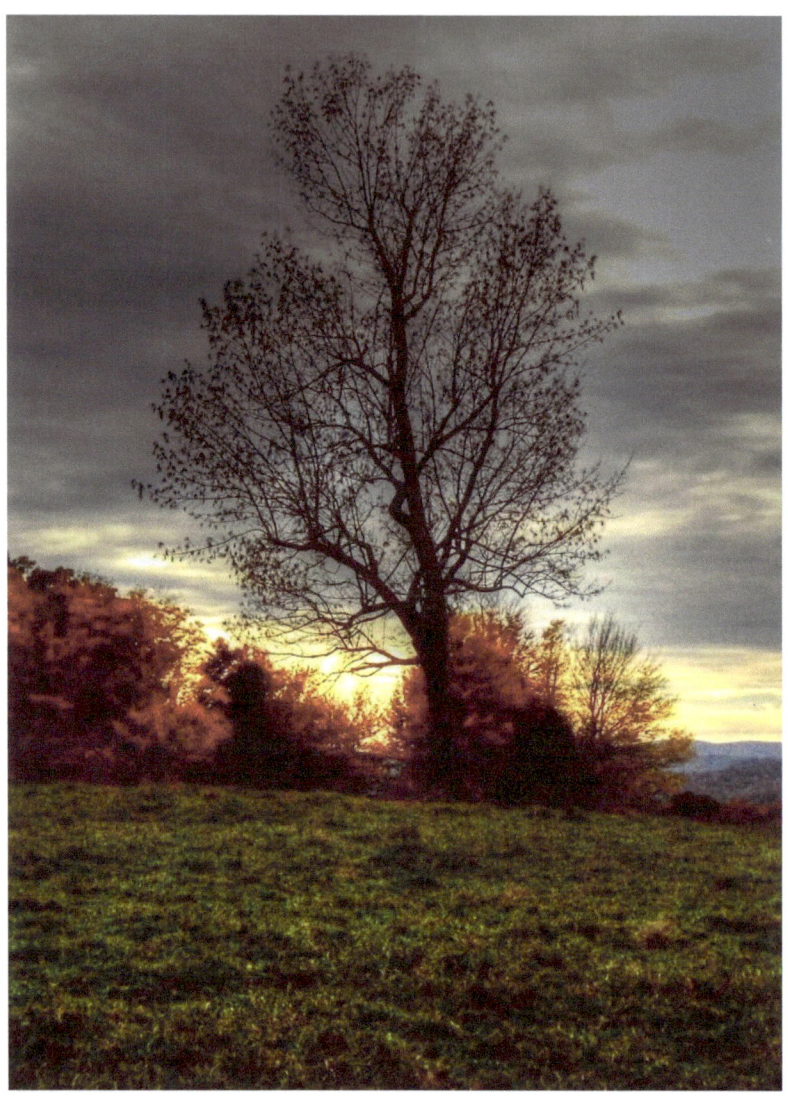

You are never too old to set another goal or to dream a new dream.
–C.S. Lewis

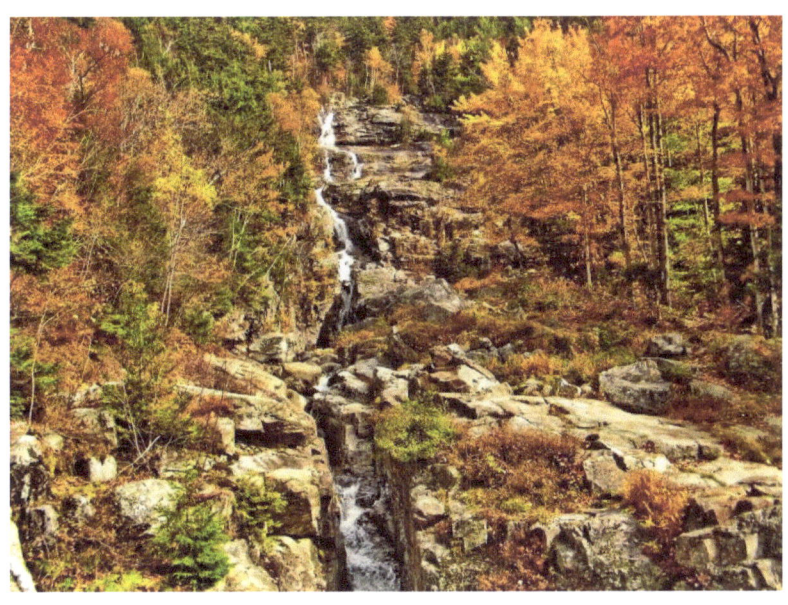

Silver Cascades – Crawford Notch

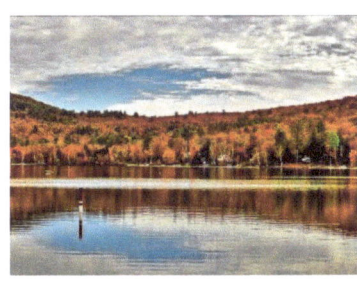
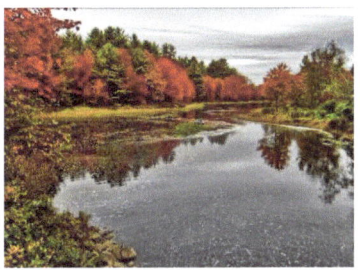

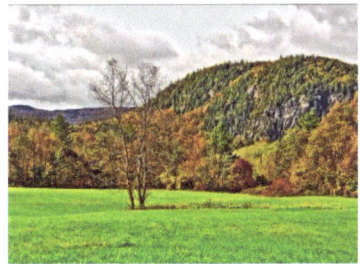

SEPTEMBER

SEPTEMBER

NEWFOUND LAKE
BRISTOL, NH

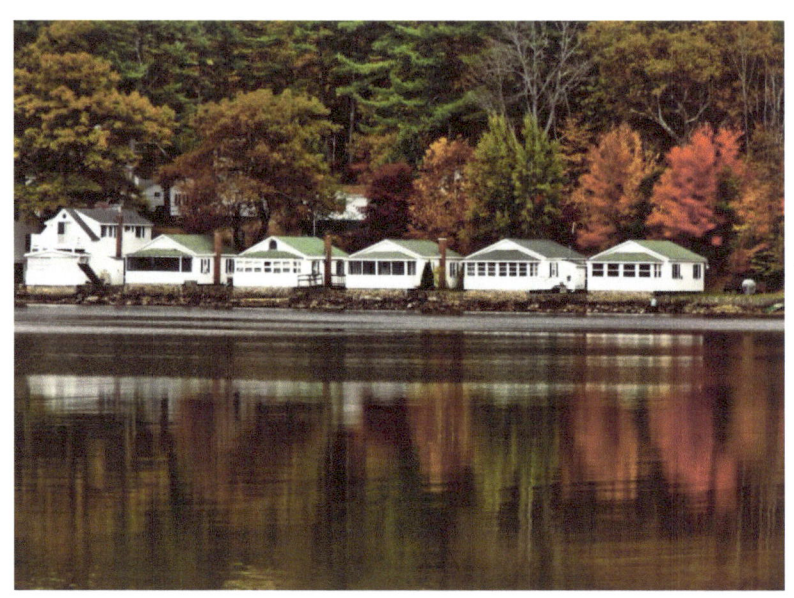

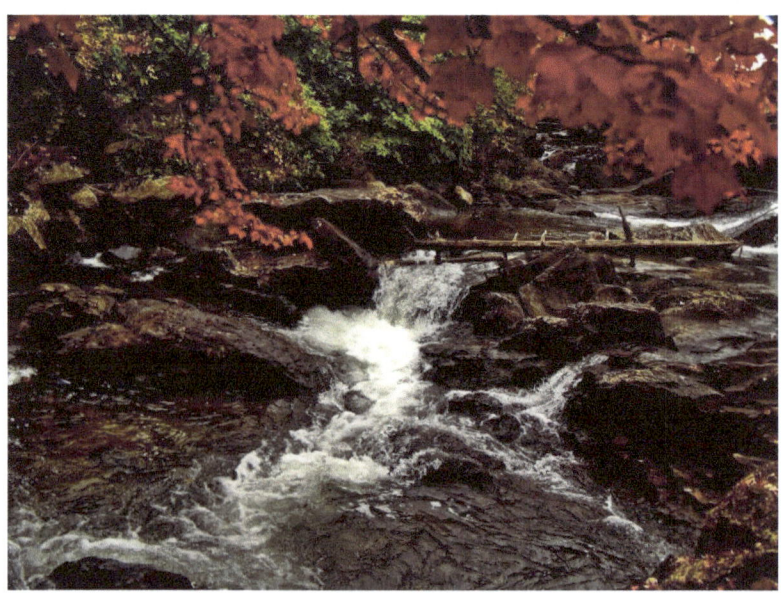

OCTOBER

OCTOBER

MOUNT AVALON
CRAWFORD NOTCH

Problems are not stop signs, they are guidelines.
–Robert H. Schuller

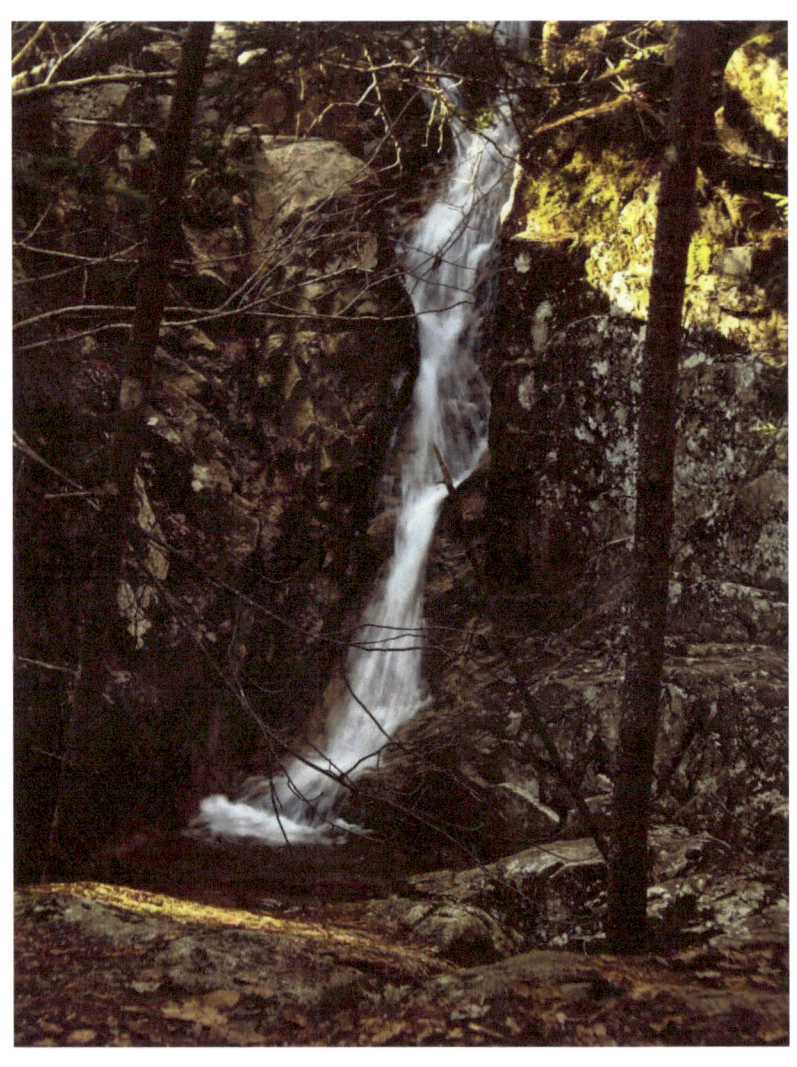

Beecher Cascades

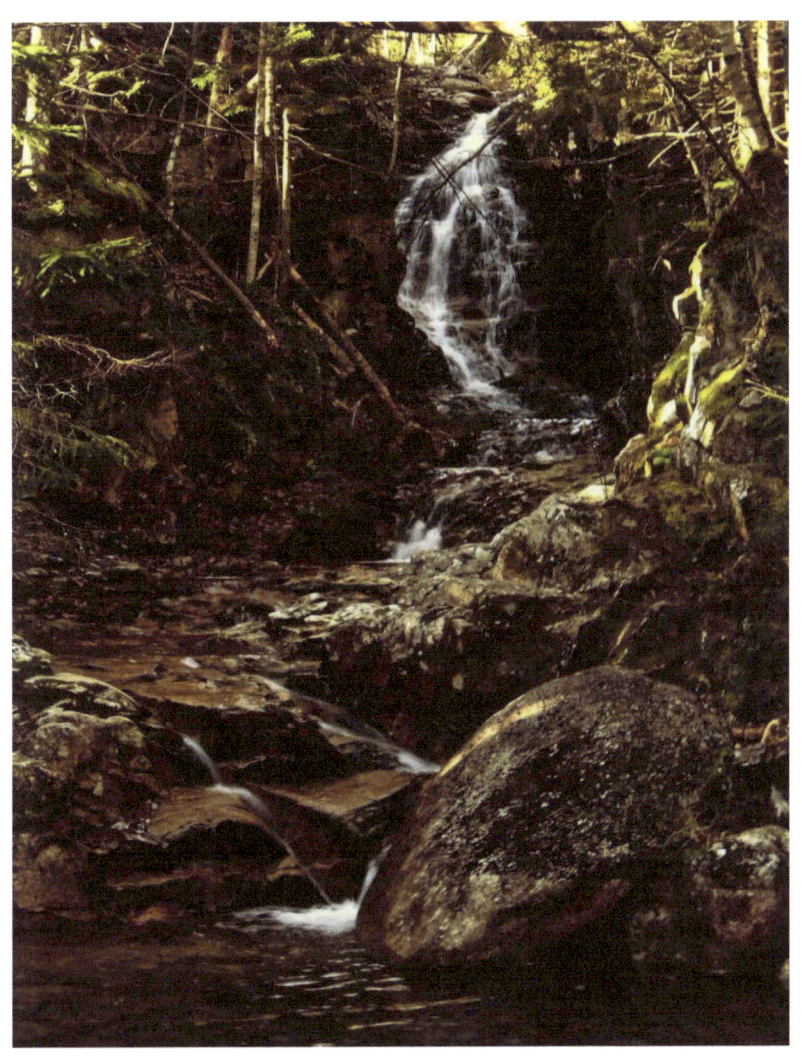

Pearl Cascades

NOVEMBER

NOVEMBER

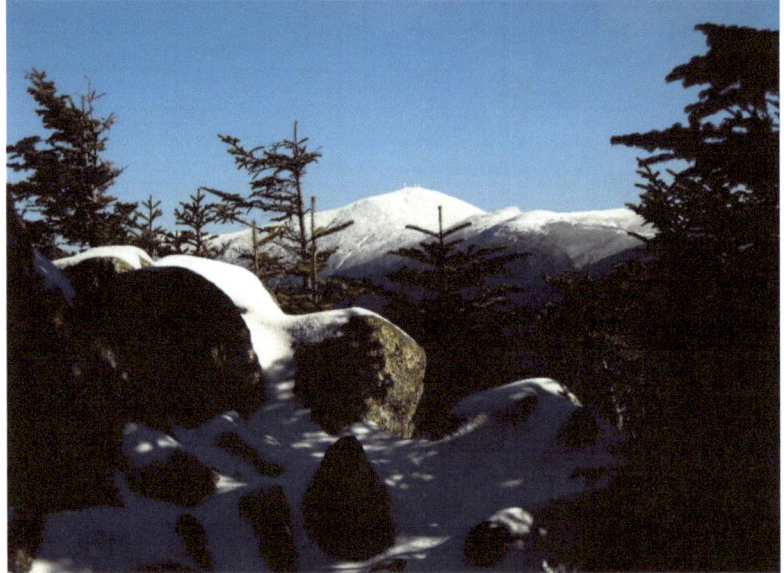
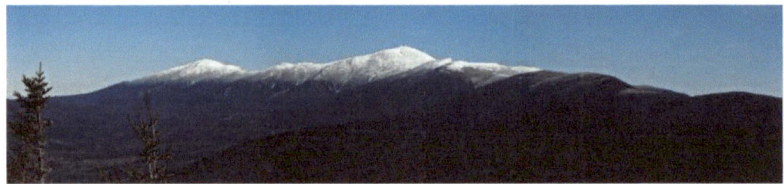

Presidential Range

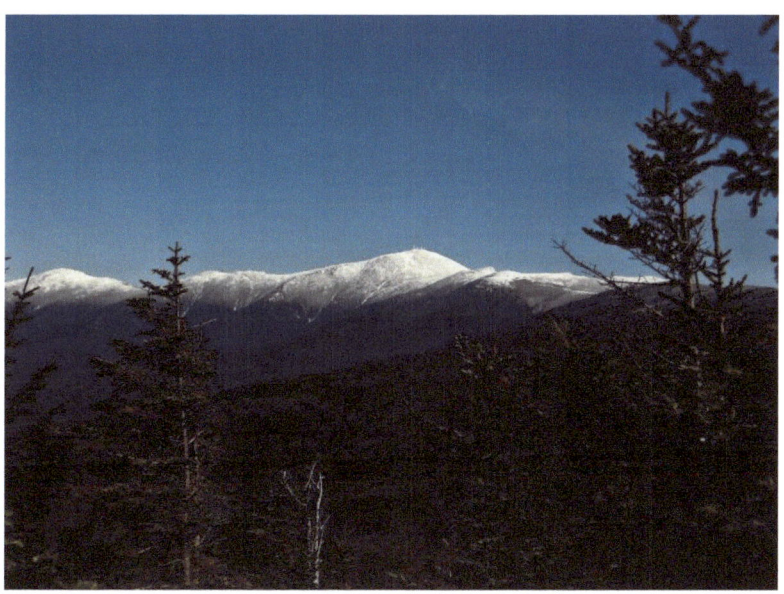

Always continue the climb. It is possible for you to do whatever you choose, if you first get to know who you are and are willing to work with a power that is greater than ourselves to do it.
–Ella Wheeler Wilcox

DECEMBER

DECEMBER

www.ingramcontent.com/pod-product-compliance
Lightning Source LLC
Chambersburg PA
CBHW040901180526
45159CB00001B/483